MARLYS HAMMER'S
TELEMARK ROSEMALING
COLORING BOOK

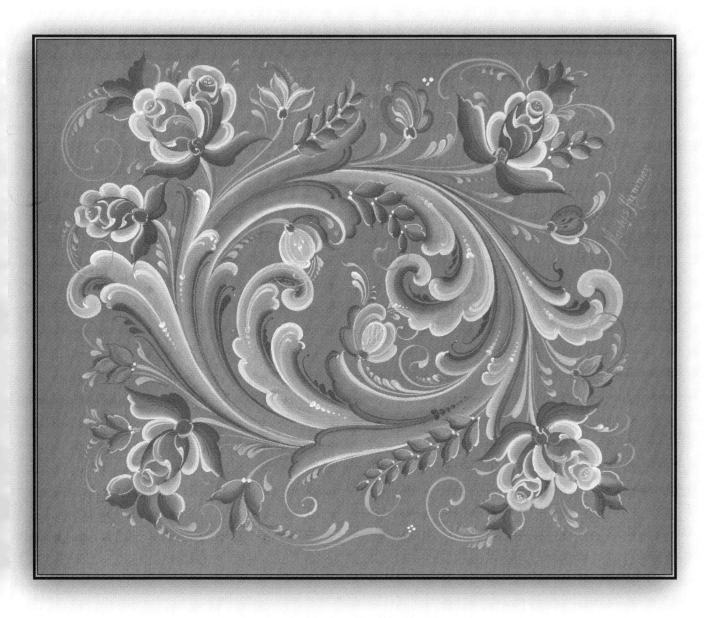

DIANE EDWARDS

Acknowledgments

Front and back cover by Deb Schense of Big Fox Publishing.

Edited by Diane Edwards and Deb Schense

If you enjoyed this book, please leave a review online. To see Marly Hammer's rosemaling designs in full color, take a look at *Marlys Hammer: Painting in the Telemark Style Using Oils and Acrylics* by Diane Edwards.

ISBN-13: 978-1096344544

Big Fox Publishing
P. O. Box 170
North Liberty, IA 52317
www.bigfoxpublishing.com
© 2019 by Diane Edwards

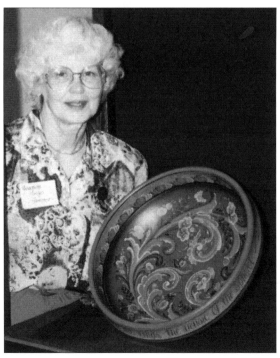

Photo courtesy Judy Ritger

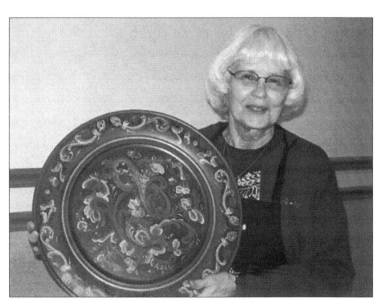

Photo courtesy Diane Edwards

Marlys Hammer displays her rosemaling artwork. The design on the left is blue edging with dark red and dark gold scroll work.. The artwork on the right is dark red with beige, dark green, and red scrolling. Marlys was a Vesterheim Gold Medalist.

About the Artist

I grew up in rural northern-central Wisconsin and have always had an interest in art, whether sketching in pencil, drawing in ink, or painting. Rosemaling came into my life about thirty-five years ago. Trips to Vesterheim in Decorah, Iowa, to study rosemaling became a regular summer experience. I attended classes taught by many Americans and Norwegian artists, including Nils Ellingsgard and Sigmund Aarseth. After receiving two Best of Show Awards and earning the required points at the National Exhibition at Vesterheim, I received my Gold Medal in 1990. Because education is part of my background, I have enjoyed teaching and sharing the beautiful art form of rosemaling throughout the United States and Japan. Meeting rosemalers is always rewarding, and sharing what I have learned is a privilege.

Having been born and raised in a Scandinavian home, it's surprising not to have heard about rosemaling until I was about forty and had a home and family of my own. My first encounter with this type of painting occurred after my mother took a class in rosemaling and shared her excitement about it with me. Drawing and painting had always been a part of my life, but rosemaling was part of my heritage and my faith. I saw the "vine and the branches" (John 15:5) in the scrolls and flowers of the Telemark style of painting. Since my grandmother came from the Telemark region of Norway, it was natural to focus on the flowing, airy style of that area.

My pursuit in the study of rosemaling began with beginner classes in River Falls, Wisconsin, and continued at Vesterheim with classes from the master rosemalers of Norway, as well as artists from America. Each teacher I studied with added to my understanding of rosemaling. It would be difficult to pick one who influenced me the most. Alfield Tangen gave wonderful advice on creating designs; Olav Fossli, on beautiful line work; Sigmund Aarseth, on motion of the design, to name a few. I discovered that there is always more to learn. It's been a wonderful experience.

—Marlys Hammer (1934–2014)

I am thrilled to be able to present the Telemark Rosemaling designs of Vesterheim Gold Medalist, Marlys Hammer to Rosemalers and those who want to be or have an interest in Rosemaling. Her style of Telemark Rosemaling and her design abilities were very advanced and especially beautiful.

Marlys's best friend, Judy Ritger, VGM, and Marlys's husband Roger Hammer, painstakingly sifted through Marlys's collection of many years of Rosemaling designs and were able to send me this wonderful group of designs. Certainly, Marlys probably had many more but this collection of many pages of her designs will take some time to go through and color!

I always loved Marlys' designs and paintings and it is with gratitude and excitement that I am able to present them to the Rosemaling world! Many of these designs were done on typing paper, tracing paper and were a little yellowed with age. I debated redoing some of them on different paper and then decided that as an artist myself, it is best to see the actual hand of the artist, little smudges, and maybe even a fingerprint here and there that makes them so much more personal and human. Marlys was a great designer and everyone, even advanced Rosemalers, can gain from the study of her work. Although she used oils in the beginning of her career, at the end she used acrylics (JoSonja's Artist's Acrylics).

Any errors in the presentation of designs or any duplicates are mine. I used every design that I was given and I hope the presentation is usable for everyone. Please do not reproduce these designs, any profits will go first to printing a book of her paintings in color and then to a Rosemaling fund designated by Judy Ritger and Roger Hammer.

Thank you!

—Diane Edwards, MA

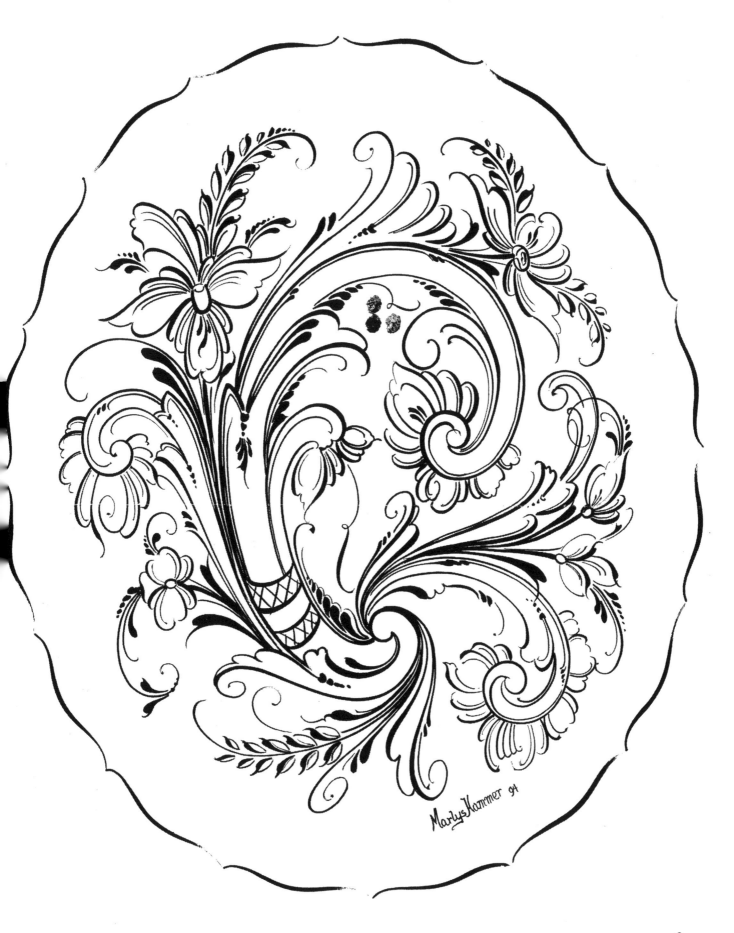

Marlys Kammer 94

—3

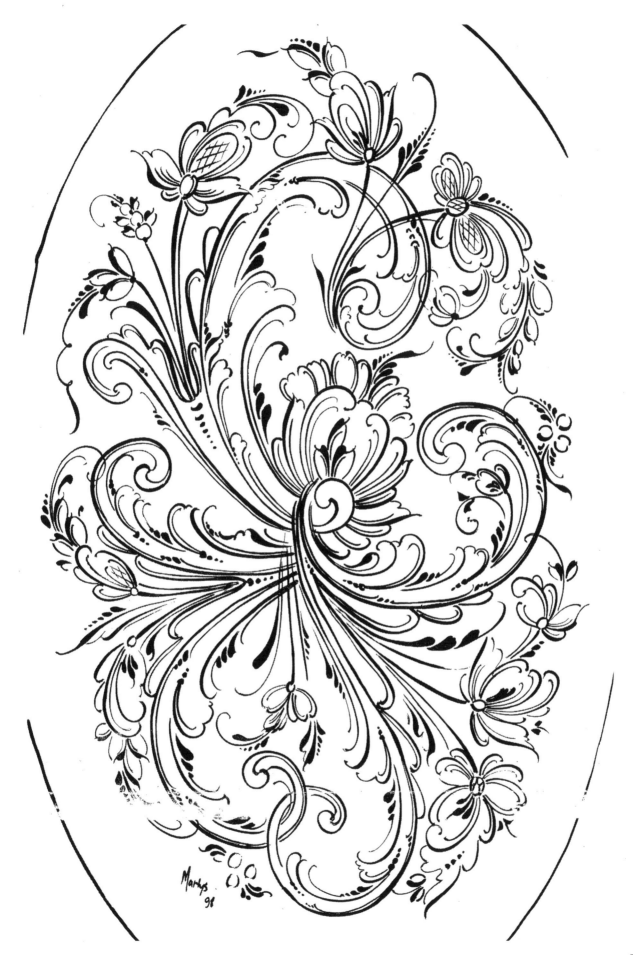

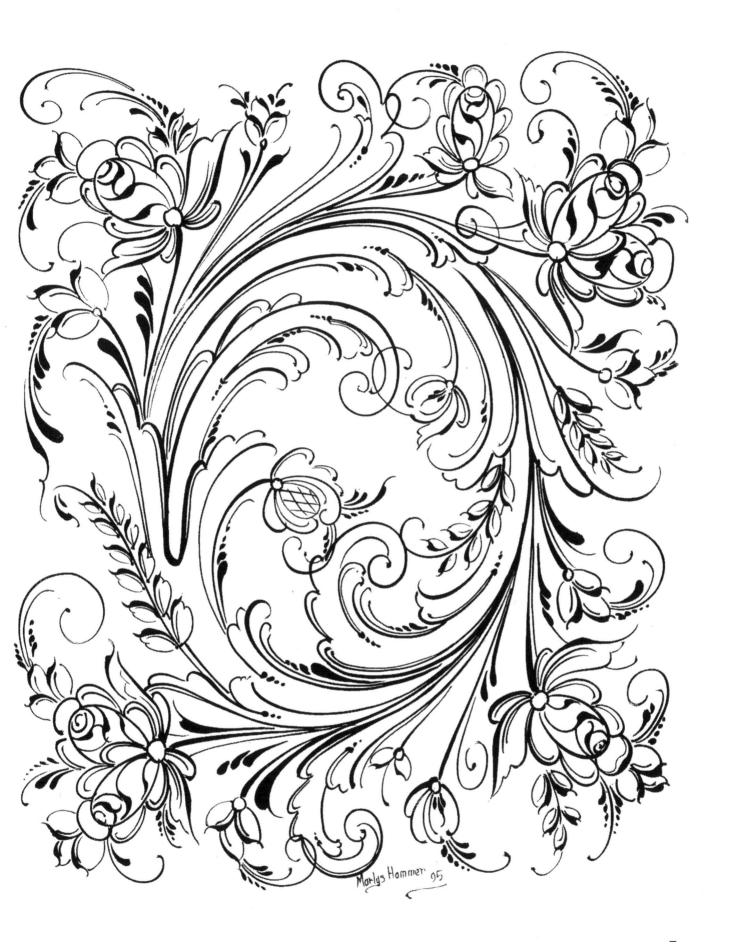

Marlys Hammer 95

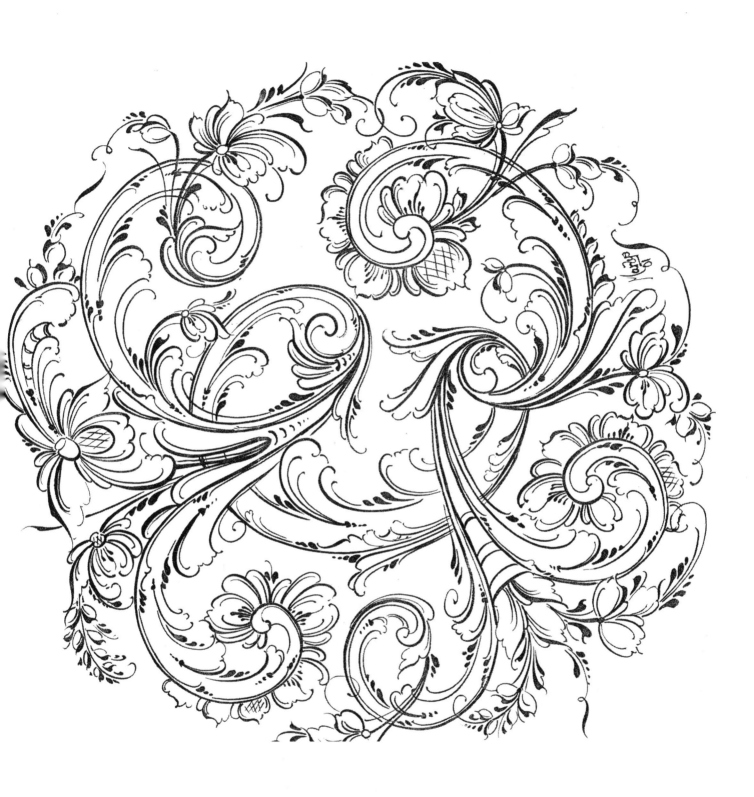

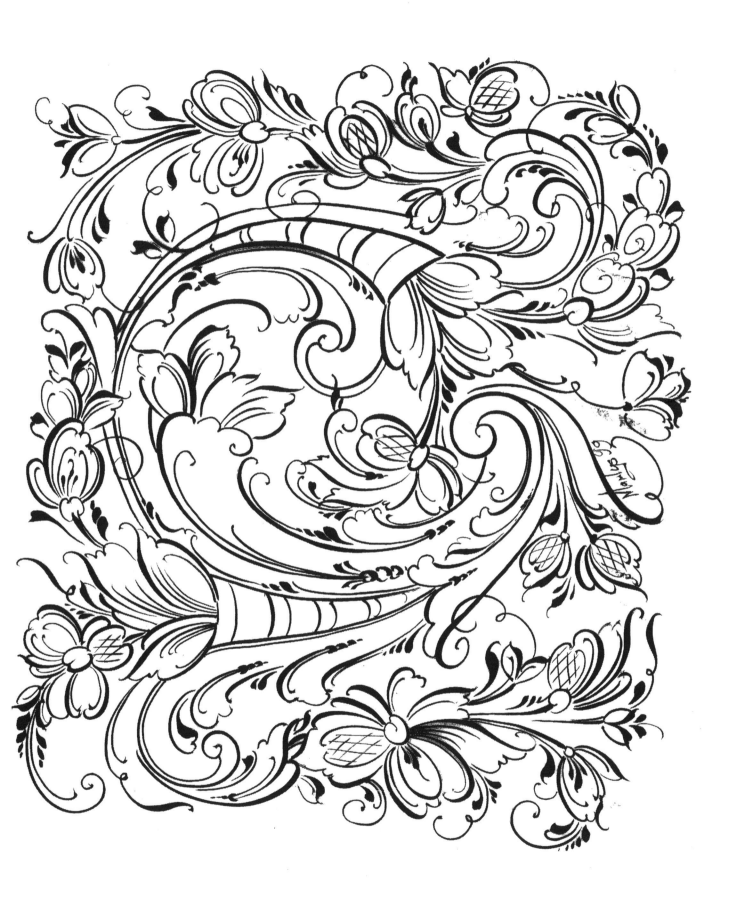

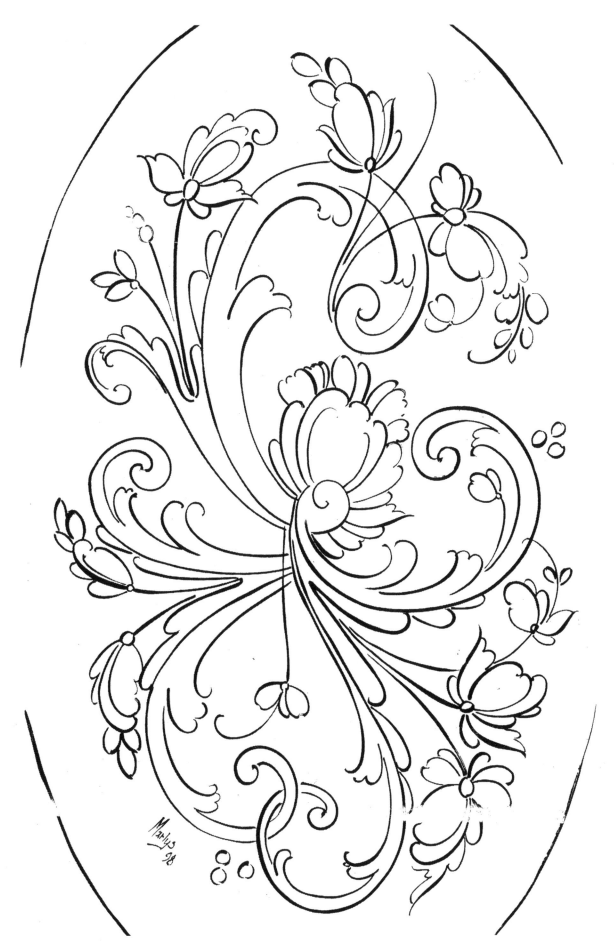

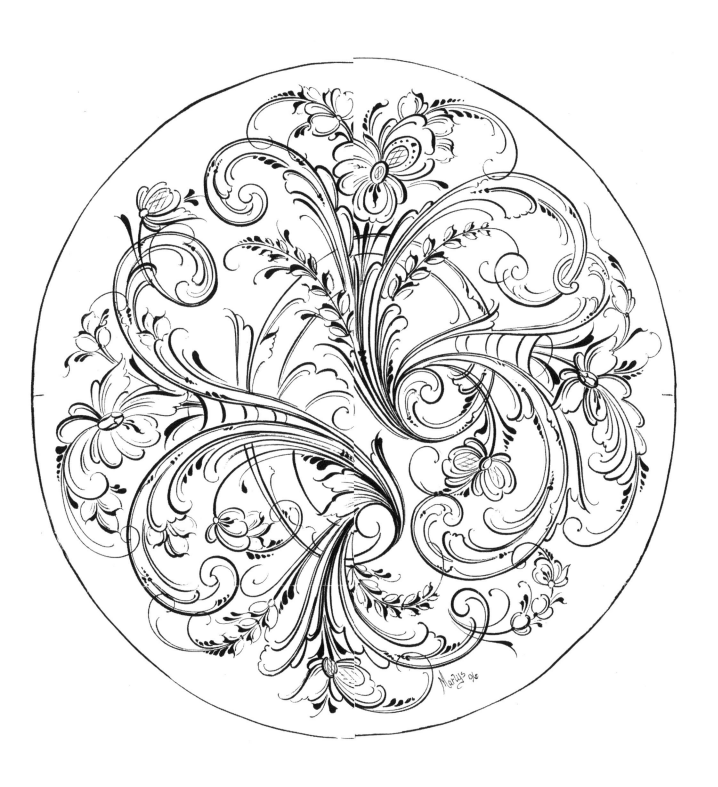

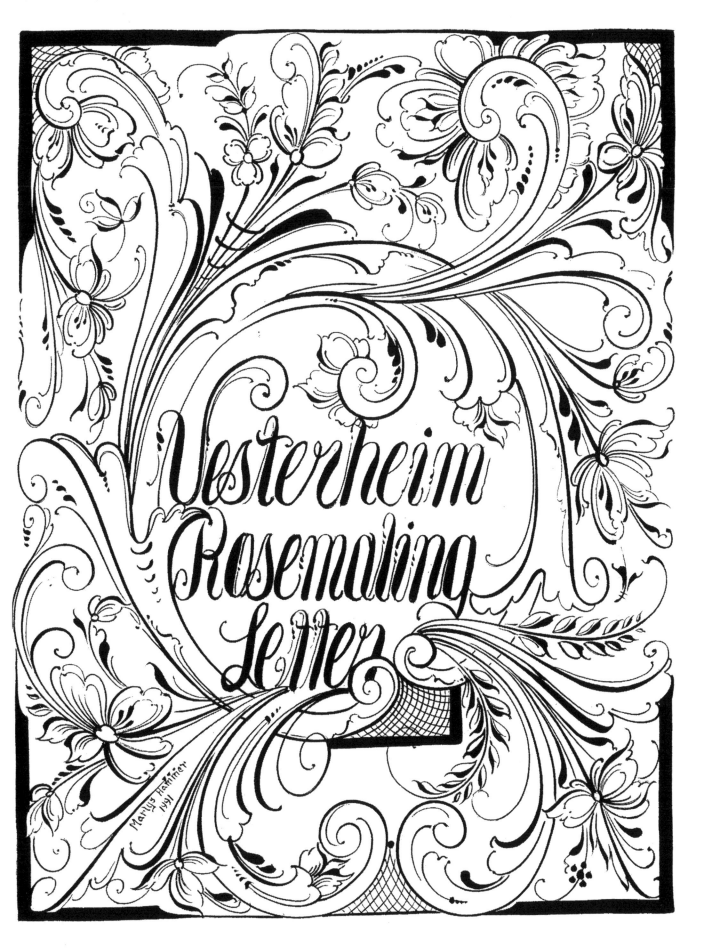

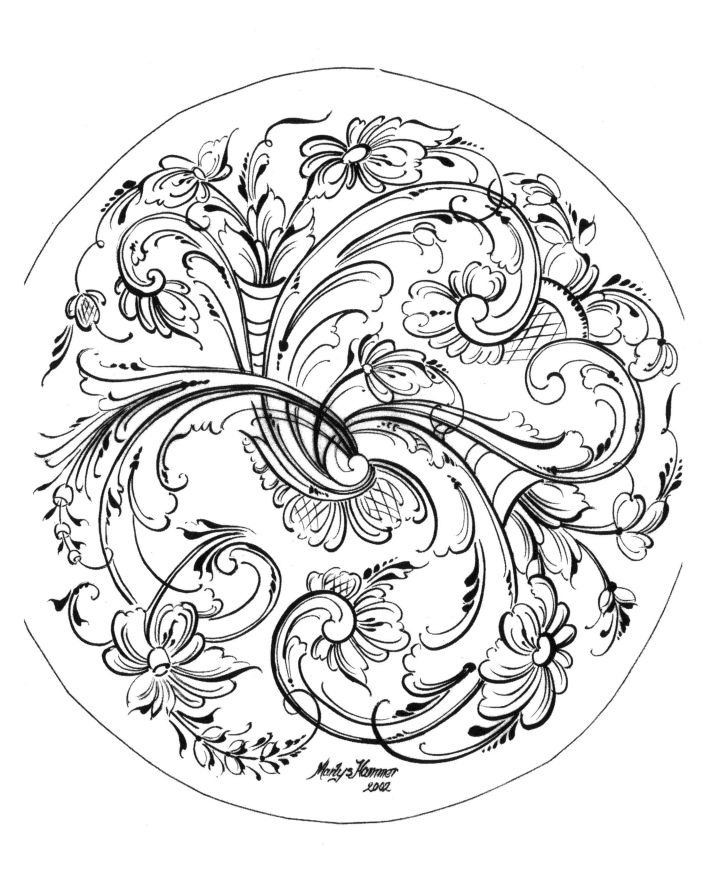

Marlys Hammer
2002

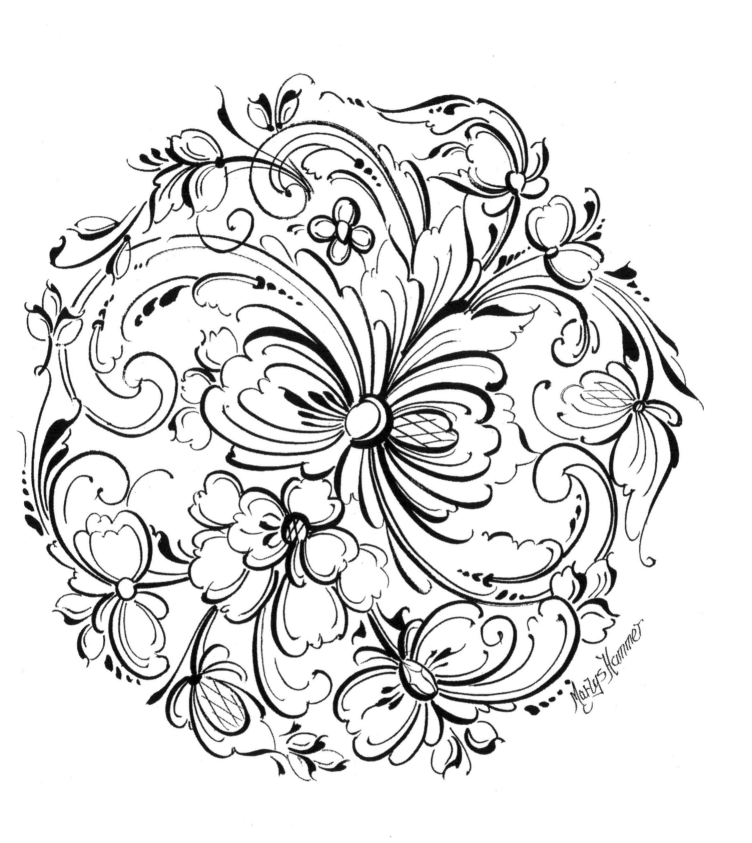

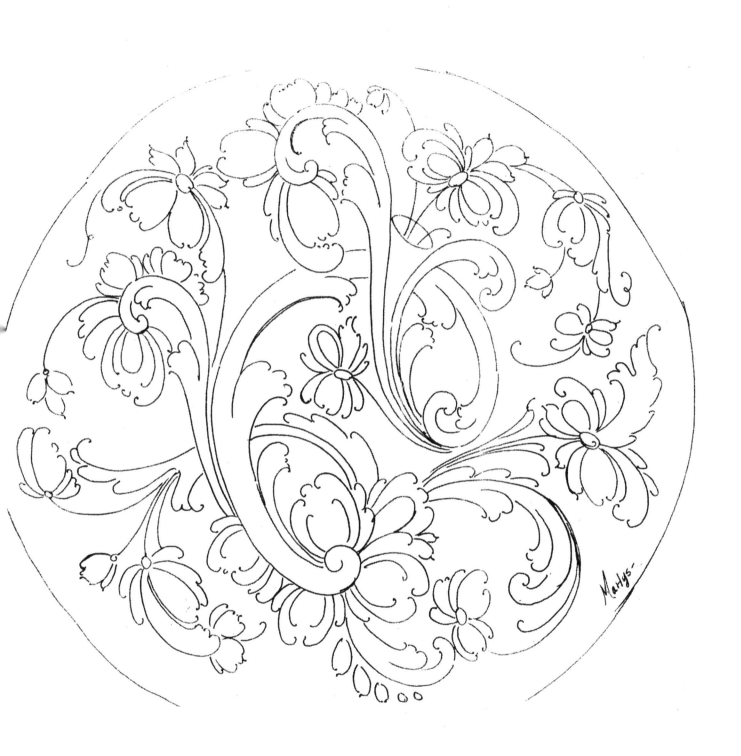

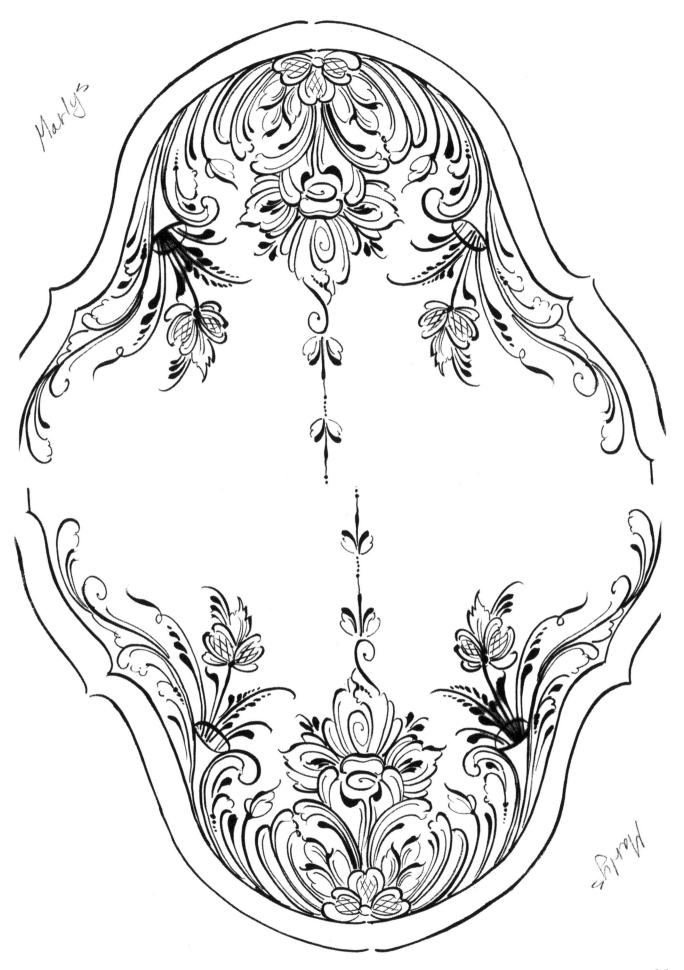

Marly's

Marly's

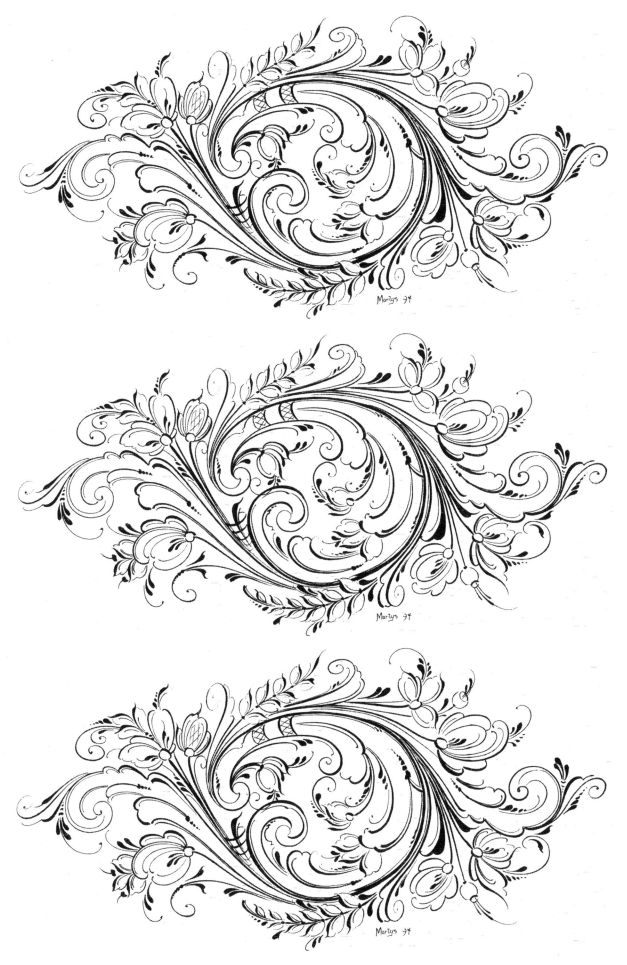

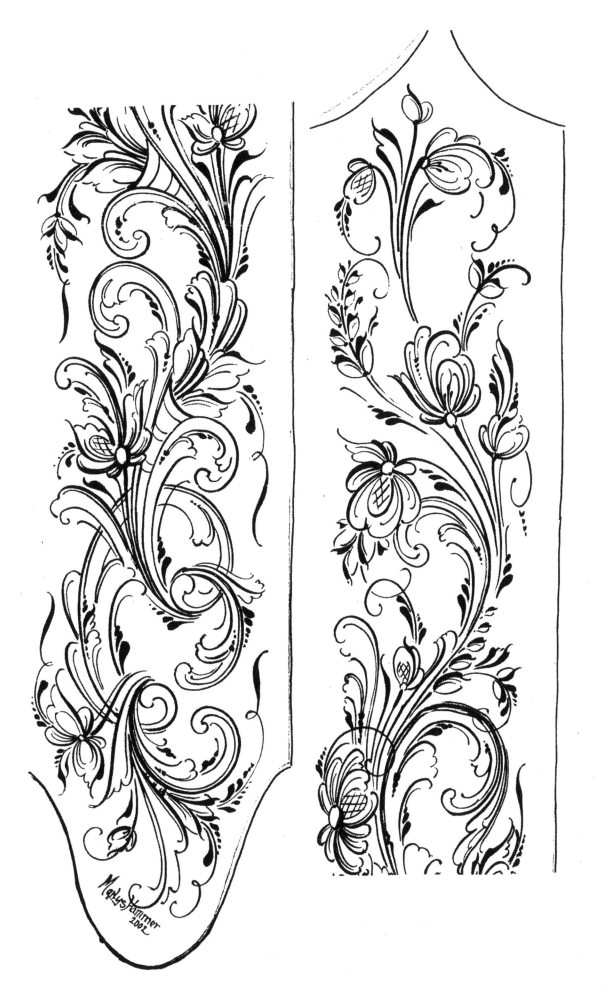

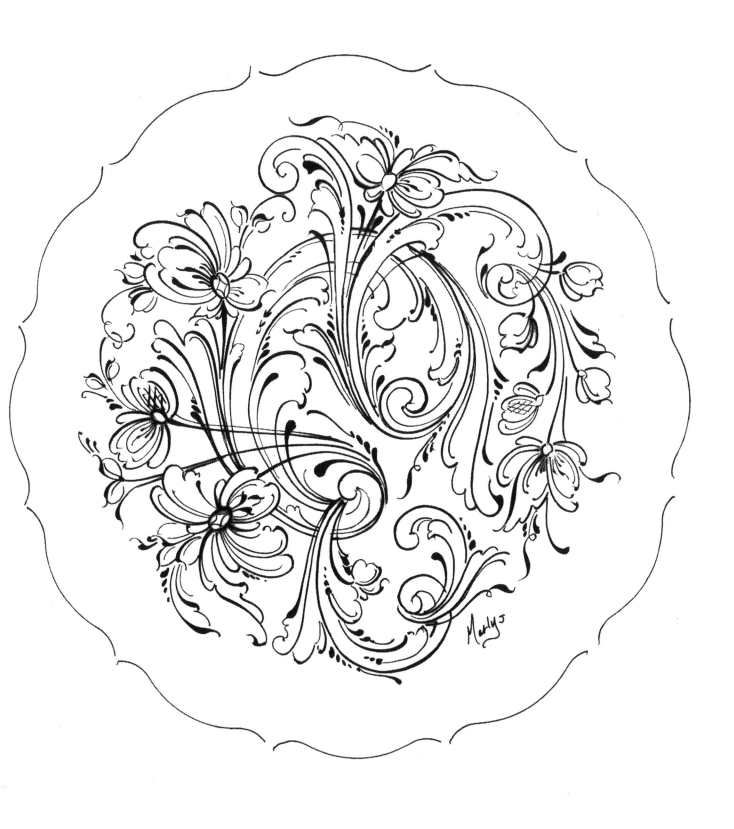

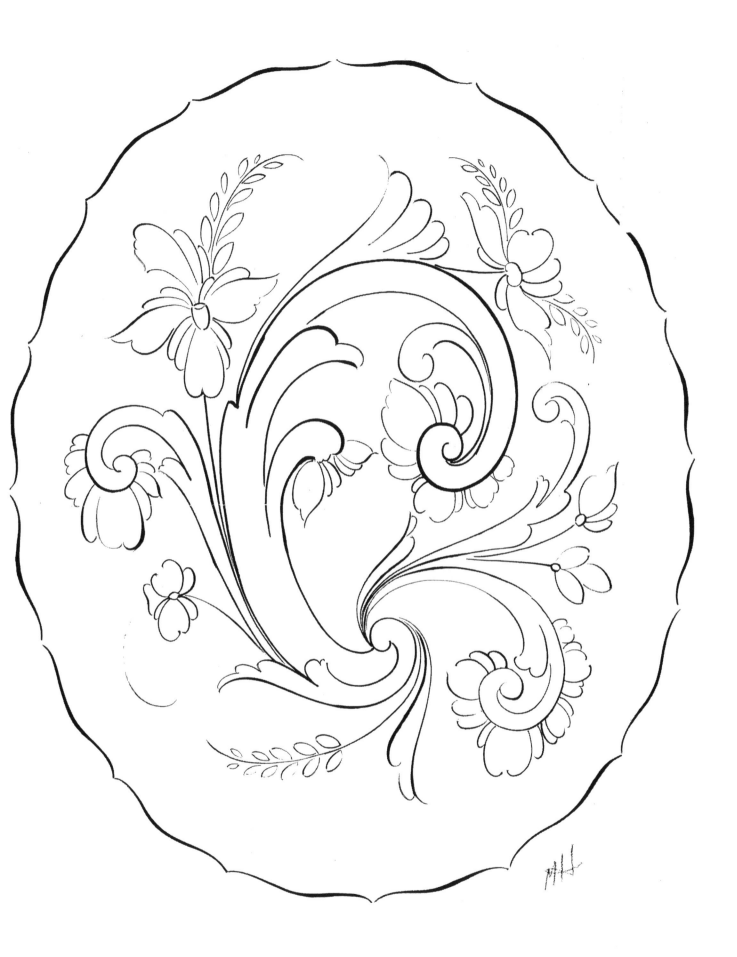

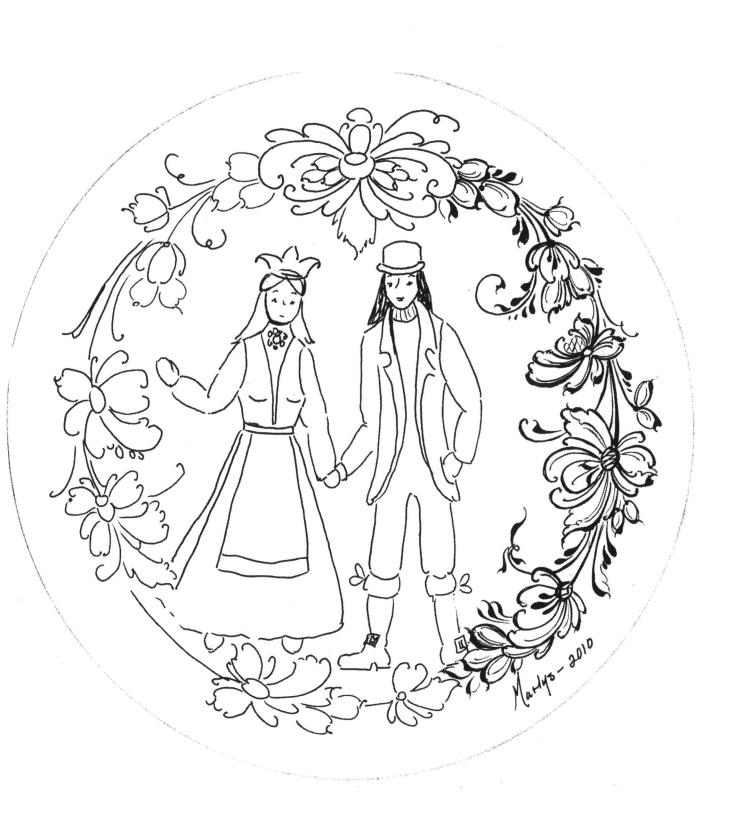

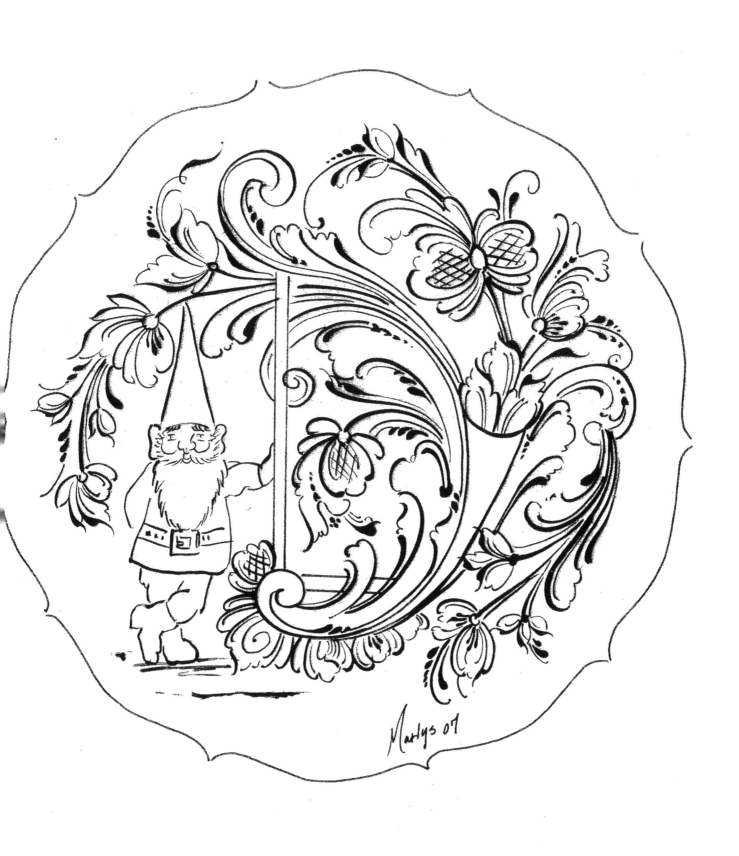

Marlys 07

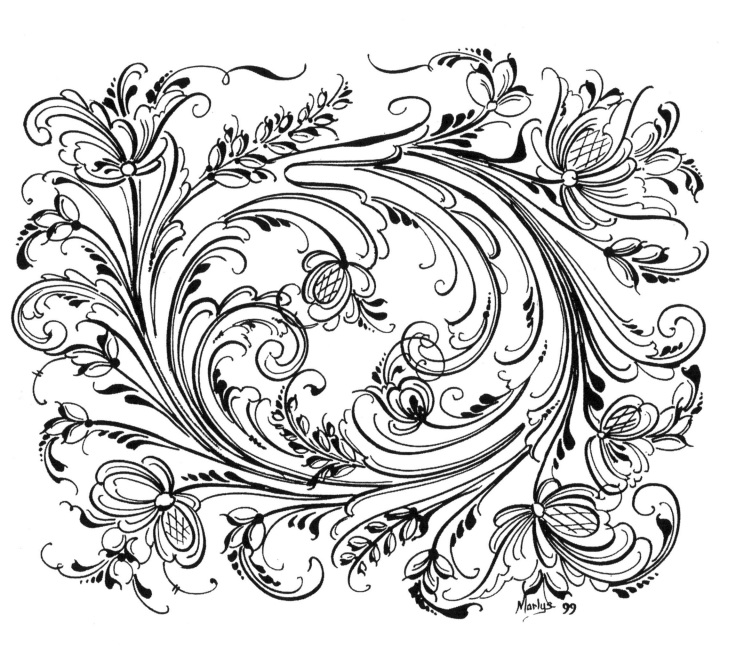

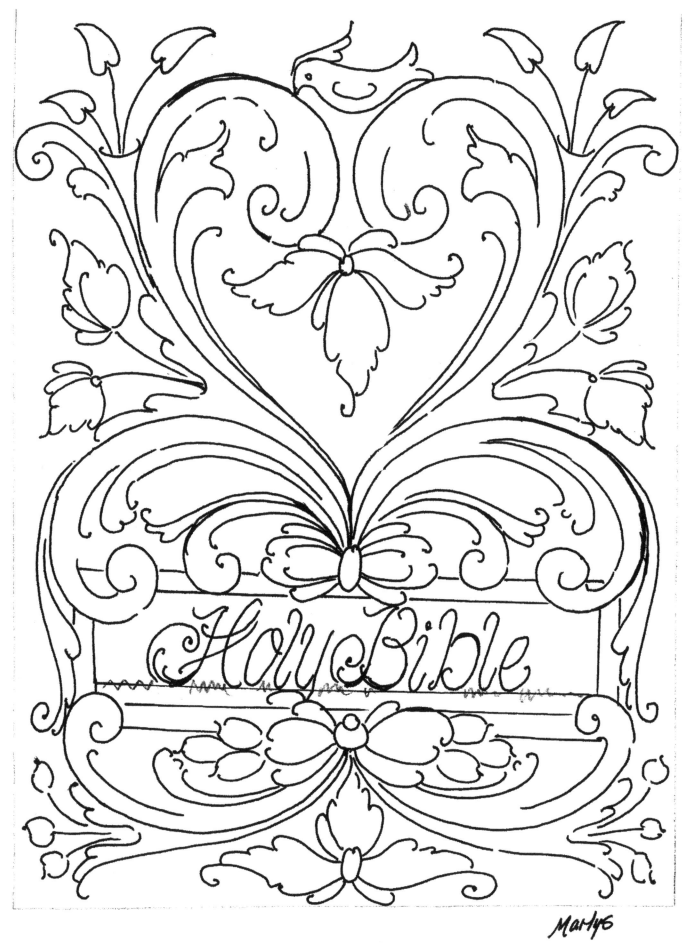

Marlys

—41

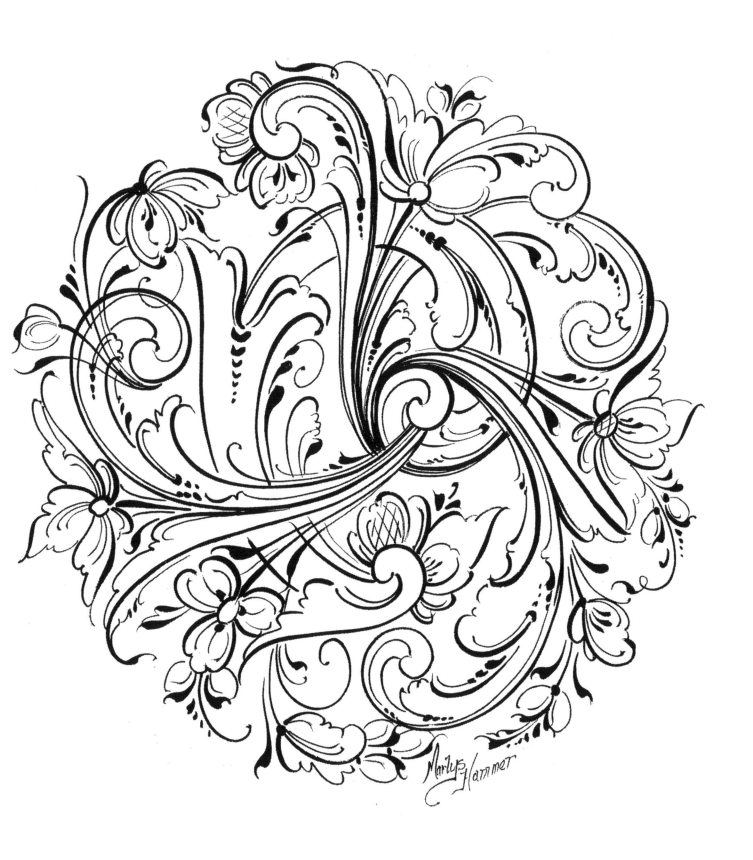

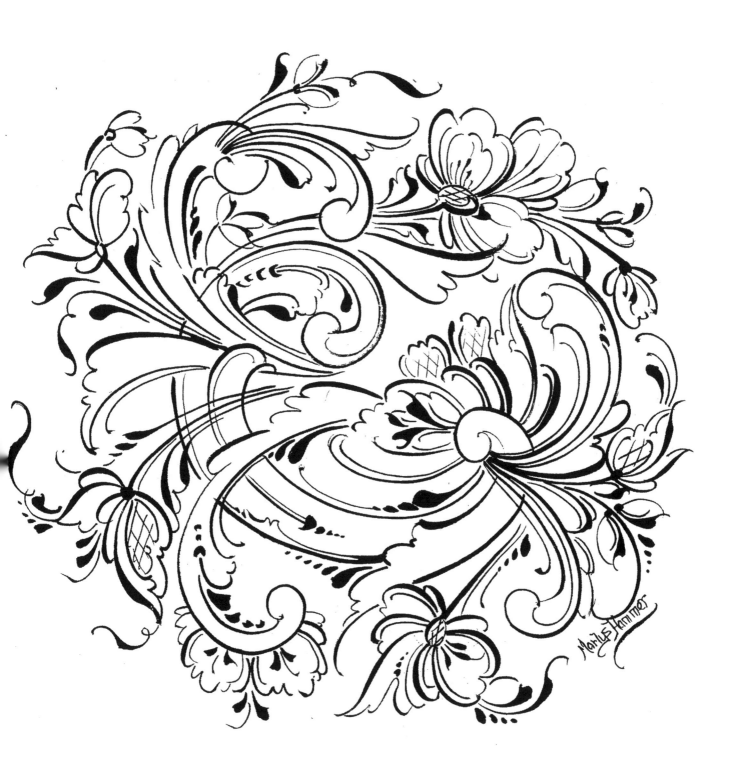

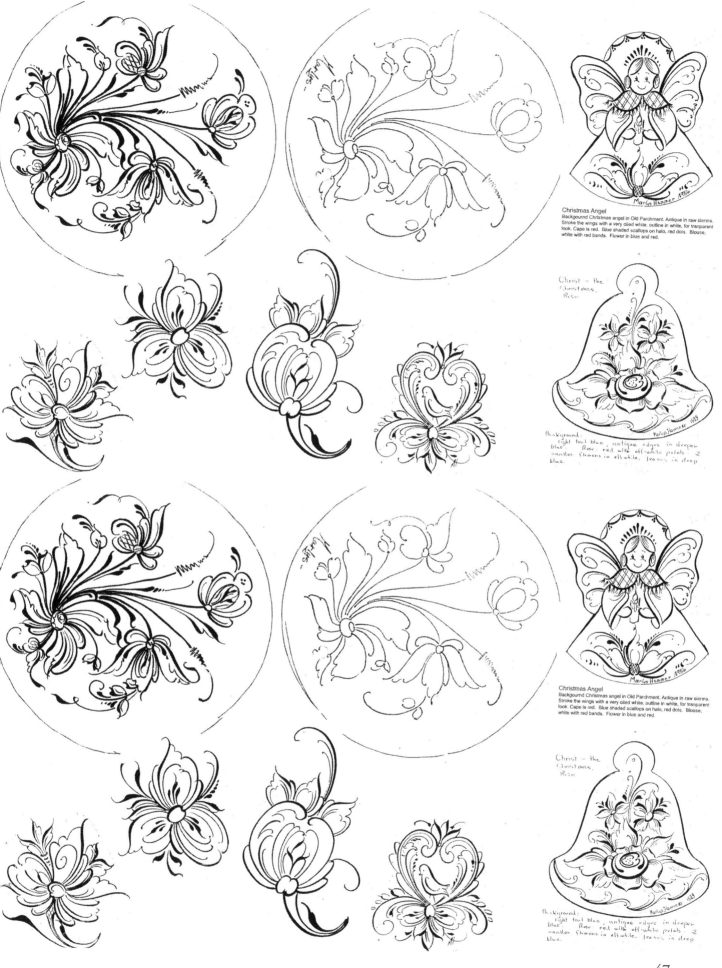

Christmas Angel
Backgournd Christmas angel in Old Parchment. Antique in raw sienna. Stroke the wings with a very oiled white, outline in white, for tranparent look. Cape is red. Blue shaded scallops on halo, red dots. Blouse, white with red bands. Flower in blue and red.

Christ – the Christmas Rose.

Background: light teal blue, antique edges in deeper blue. Rose: red with off-white petals. 2 smaller flowers in off-white, leaves in deep blue.

Christmas Angel
Backgournd Christmas angel in Old Parchment. Antique in raw sienna. Stroke the wings with a very oiled white, outline in white, for tranparent look. Cape is red. Blue shaded scallops on halo, red dots. Blouse, white with red bands. Flower in blue and red.

Christ – the Christmas Rose.

Background: light teal blue, antique edges in deeper blue. Rose: red with off-white petals. 2 smaller flowers in off-white, leaves in deep blue.

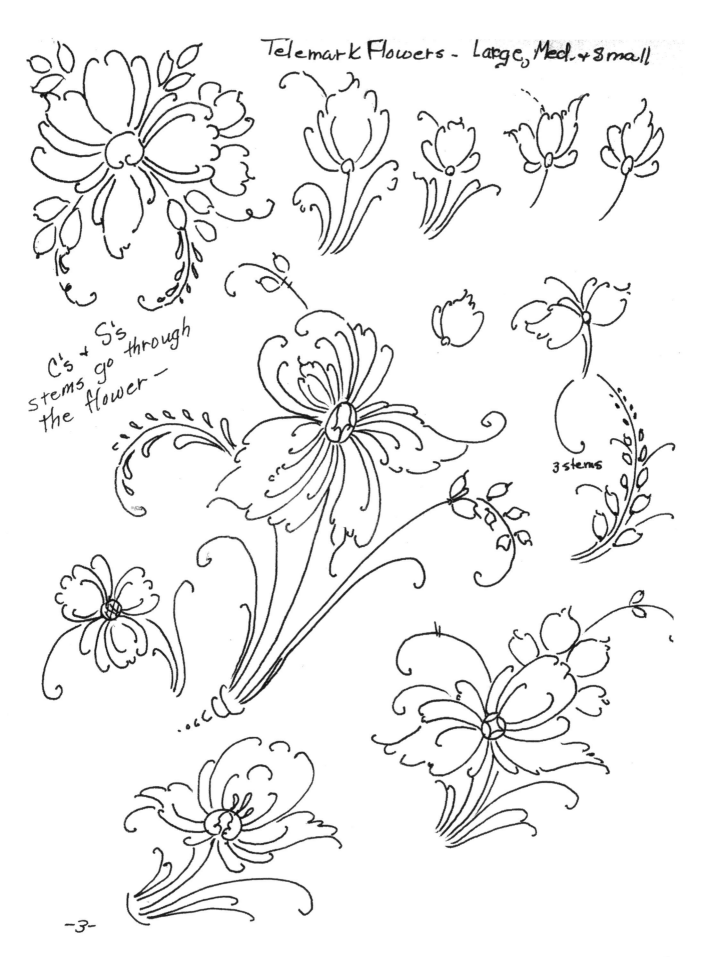

Telemark Flowers - Large, Med. + Small

C's + S's stems go through the flower —

3 stems

-3-

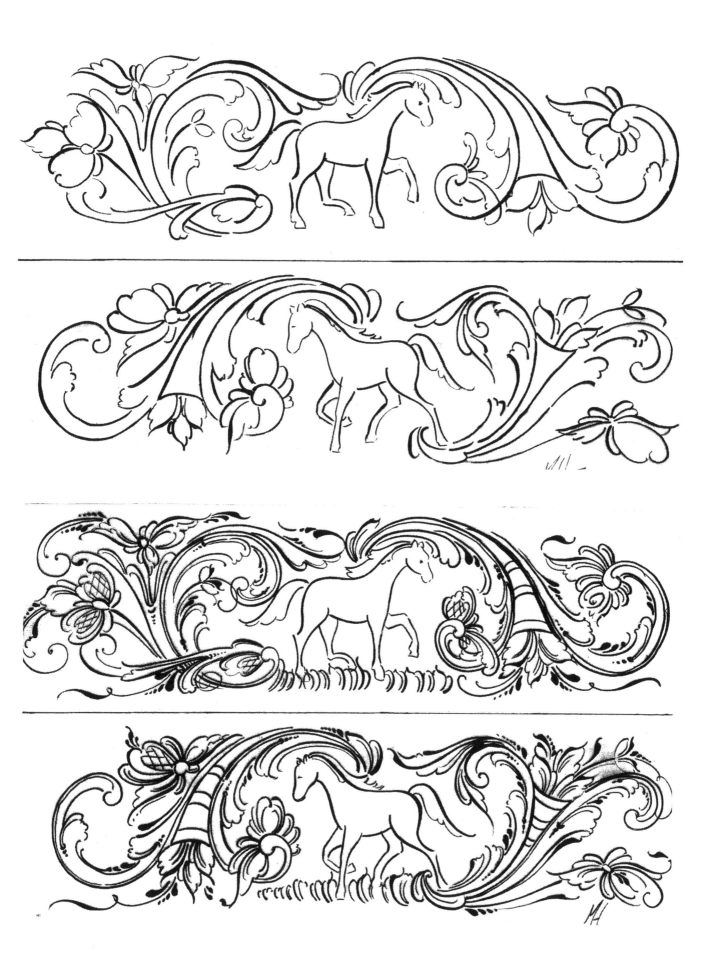

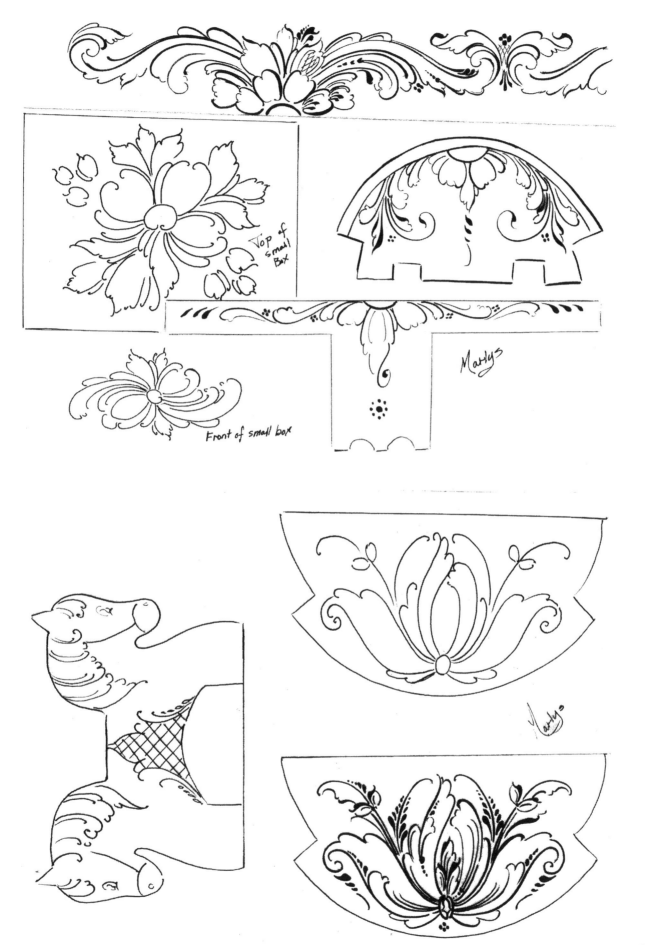

Top of small Box

Marlys

Front of small box

Marlys

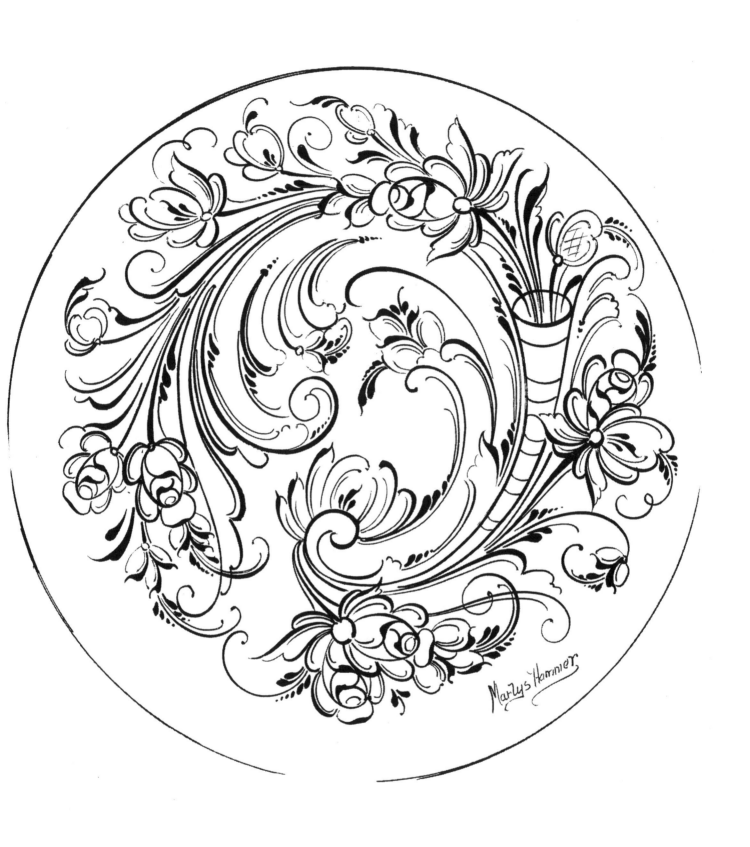

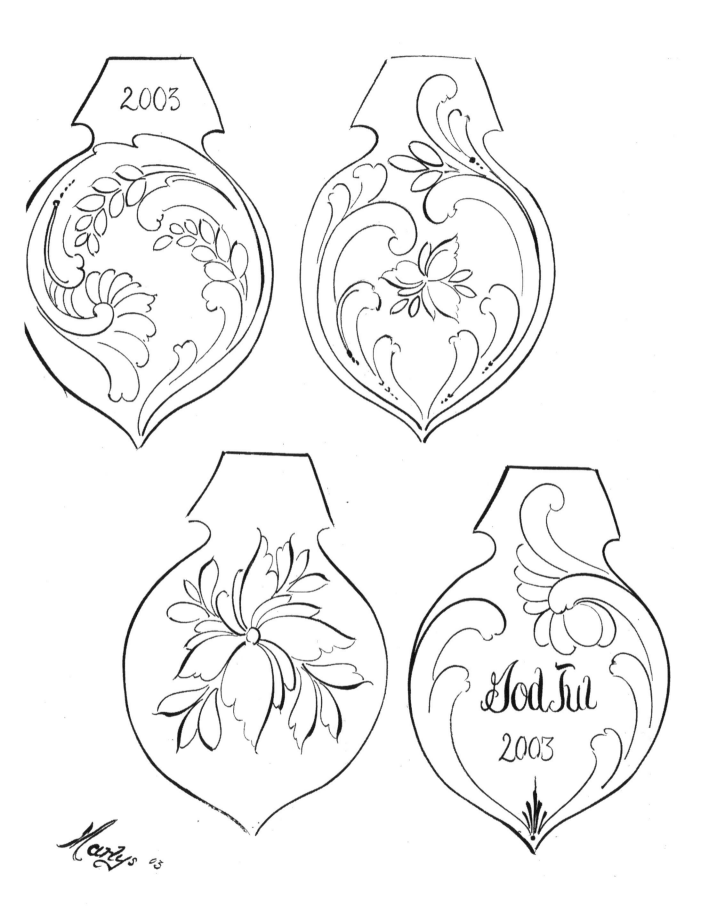

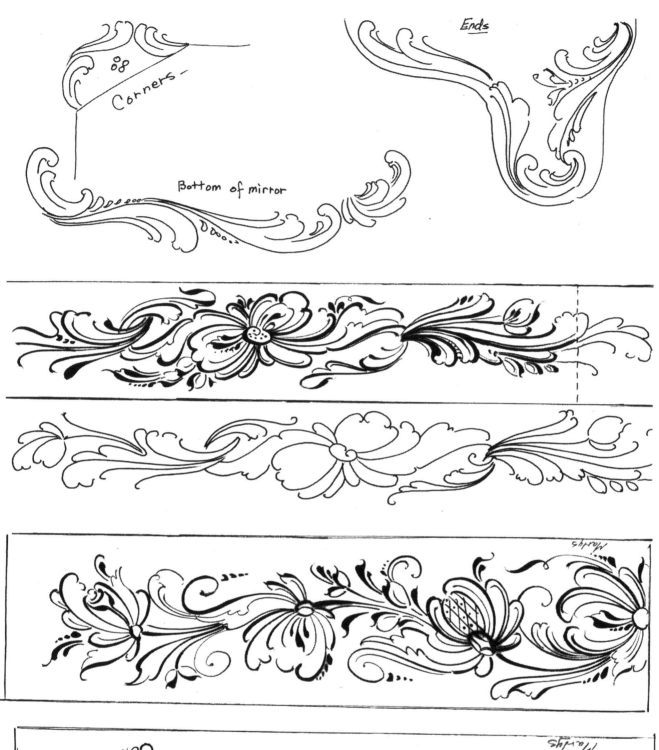

Ends

08
Corners

Bottom of mirror

Maihys

Maihys

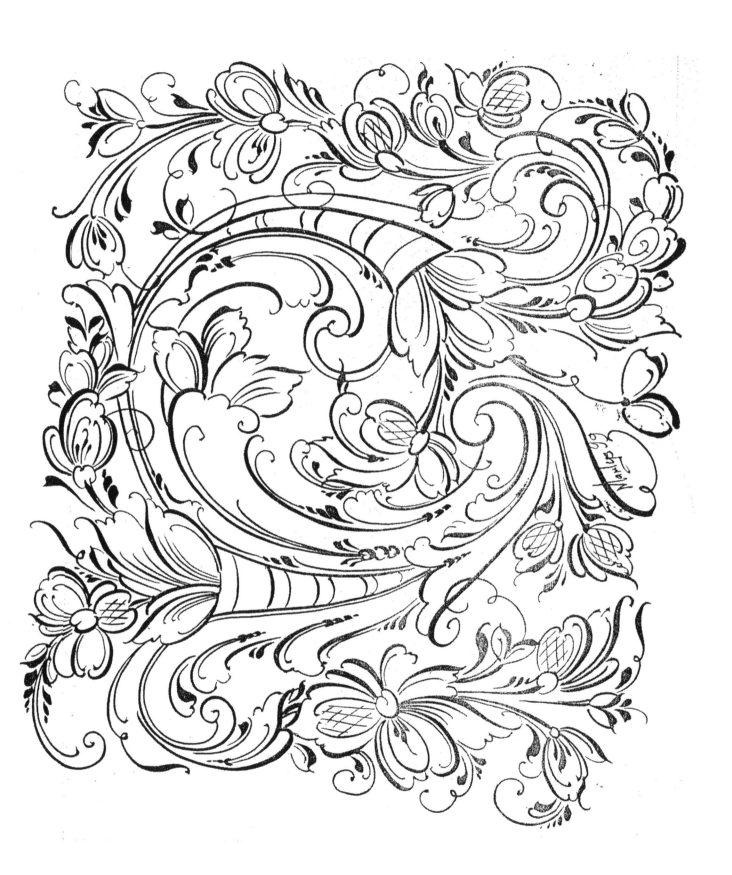

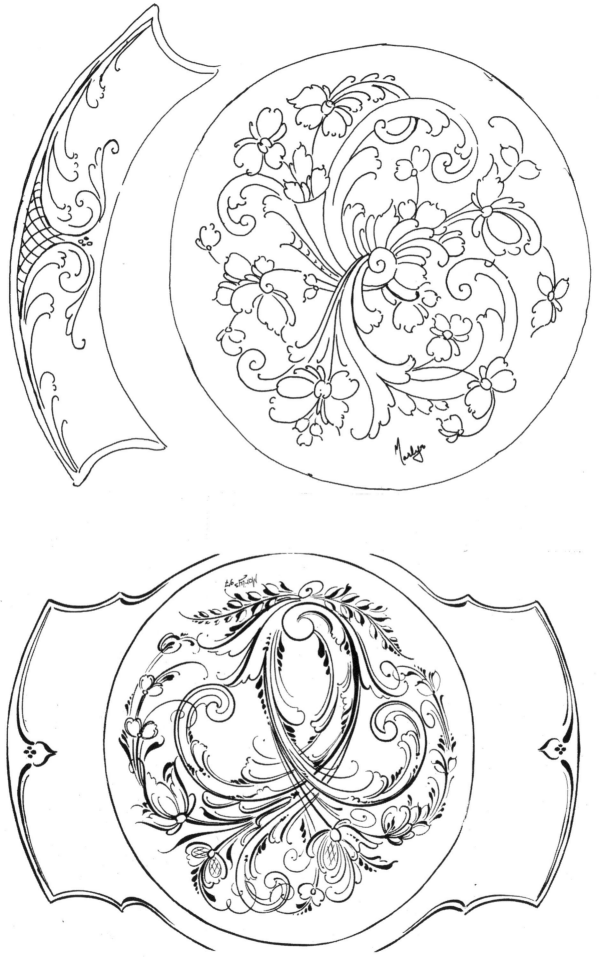

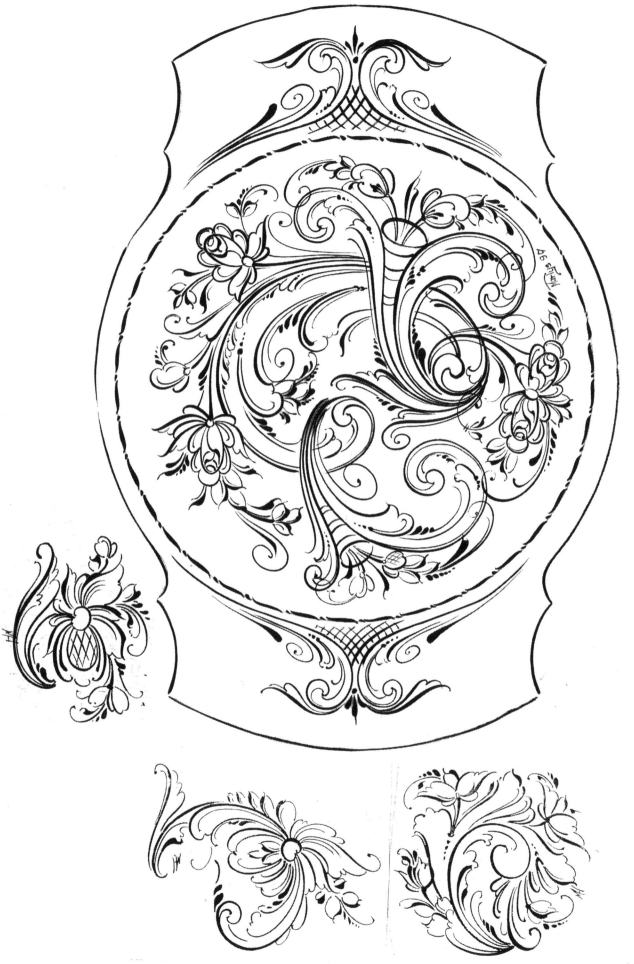

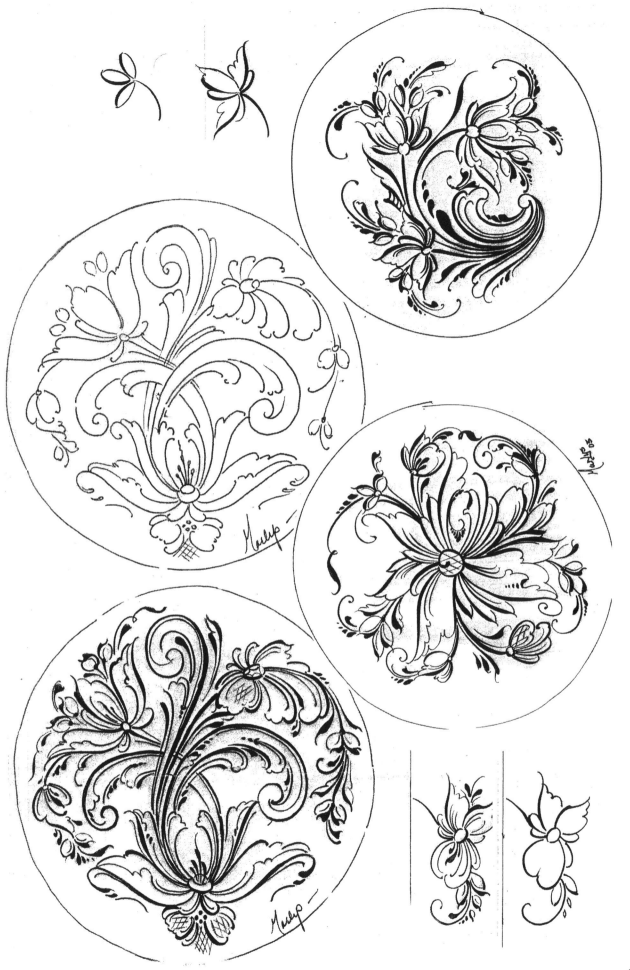

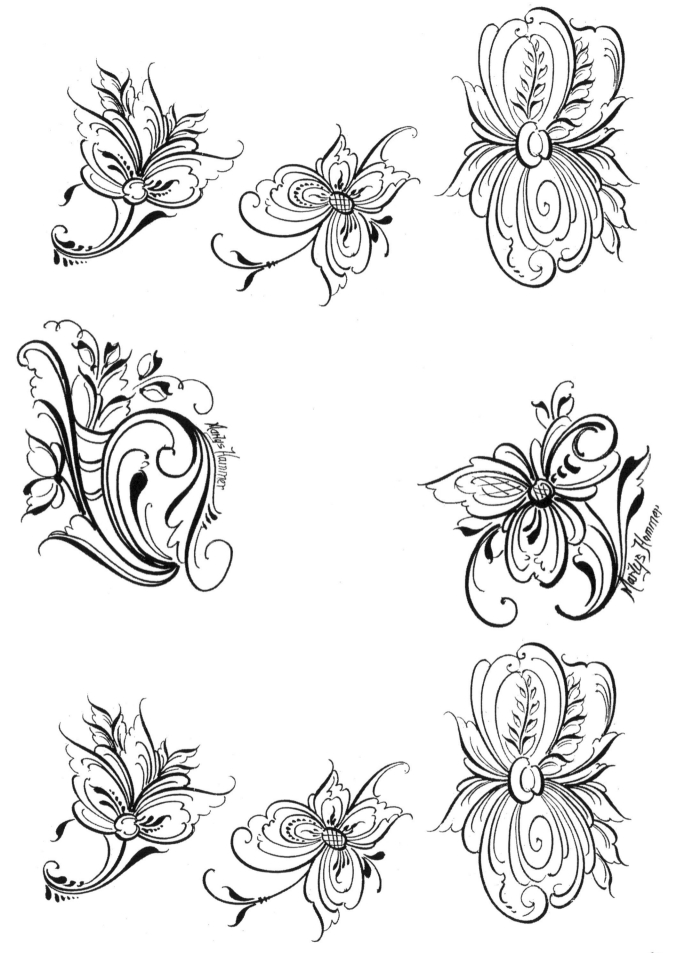

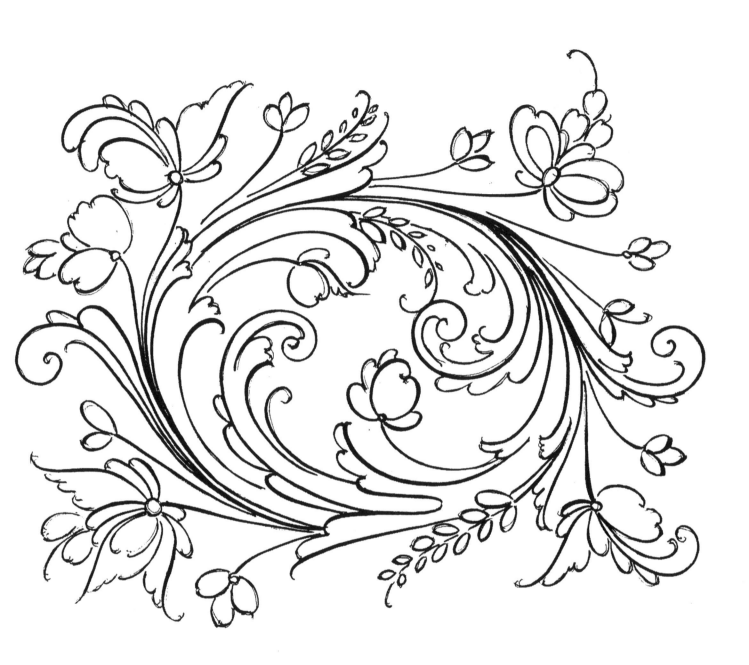

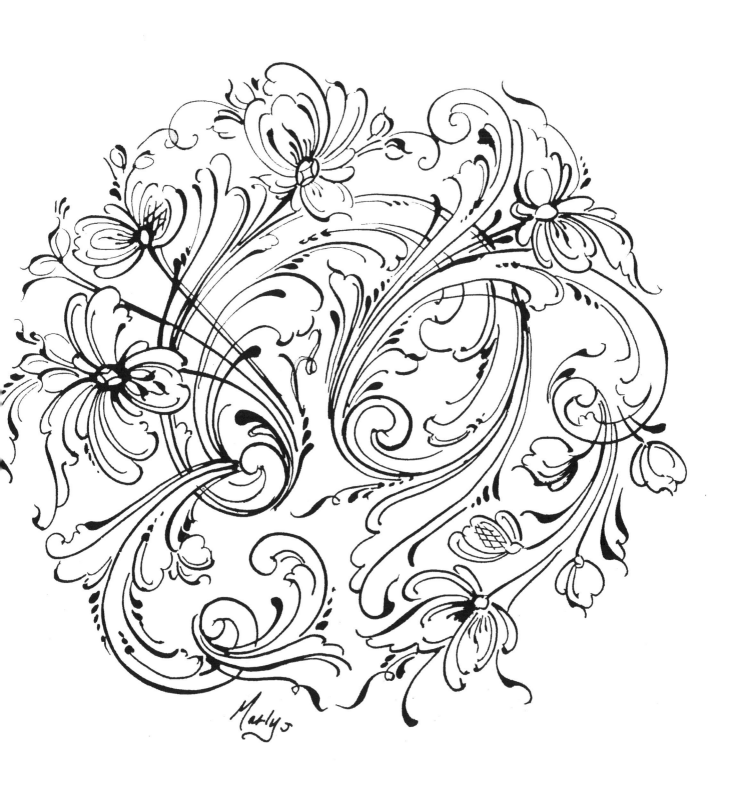

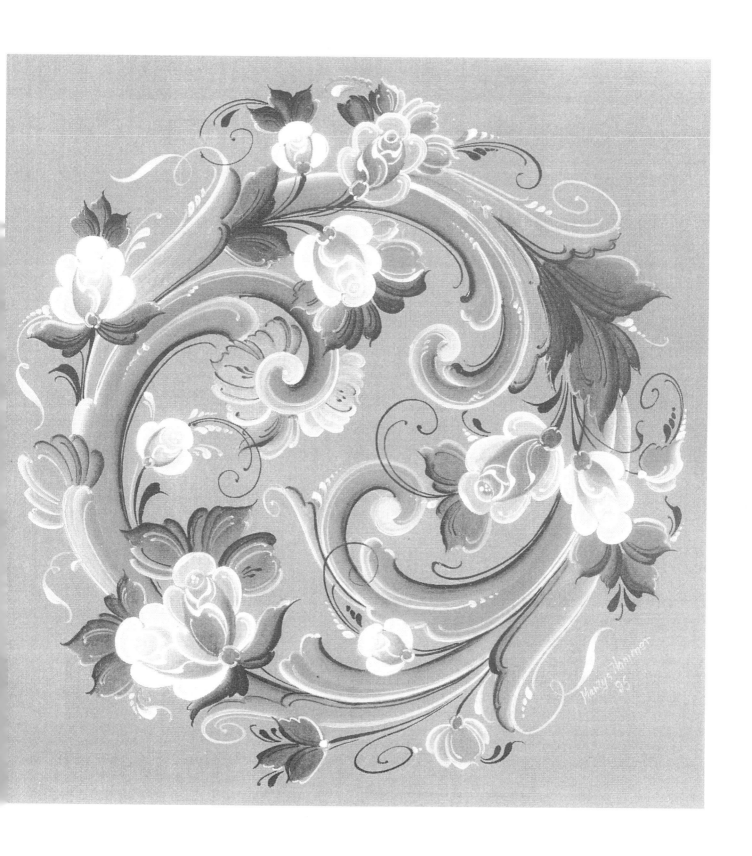

Made in the USA
Middletown, DE
16 November 2024

64697372R00044